001

002

003

004

005

006

007

008

009

010

Victorian 1

011

012

013

014

015

016

017

018

019

020

021

022

023

024

025

026

027

028

029

031

030

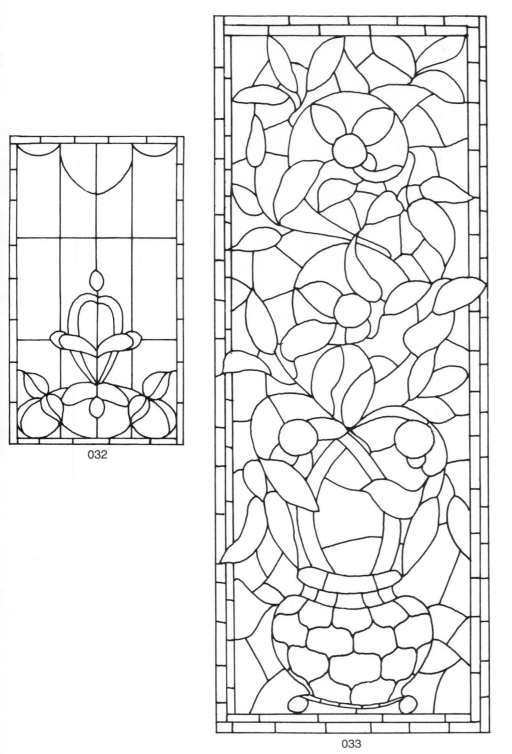

032

033

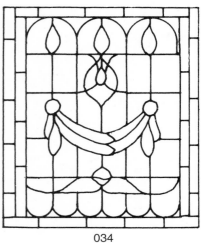

034

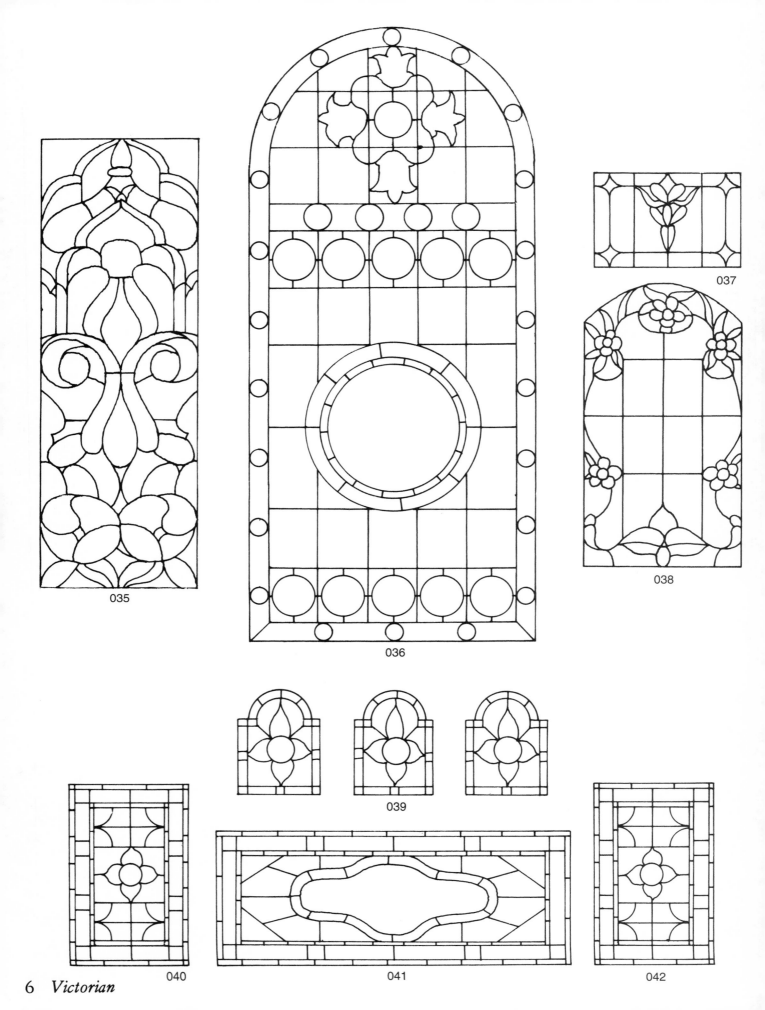

035

036

037

038

039

040

041

042

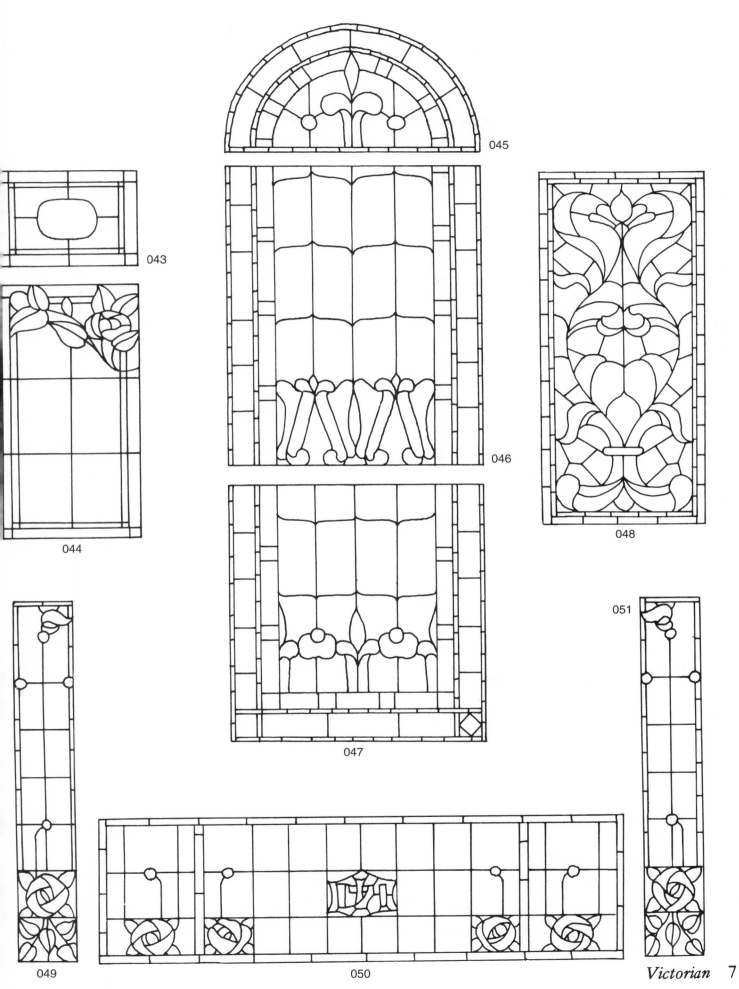

043

044

045

046

047

048

049

050

051

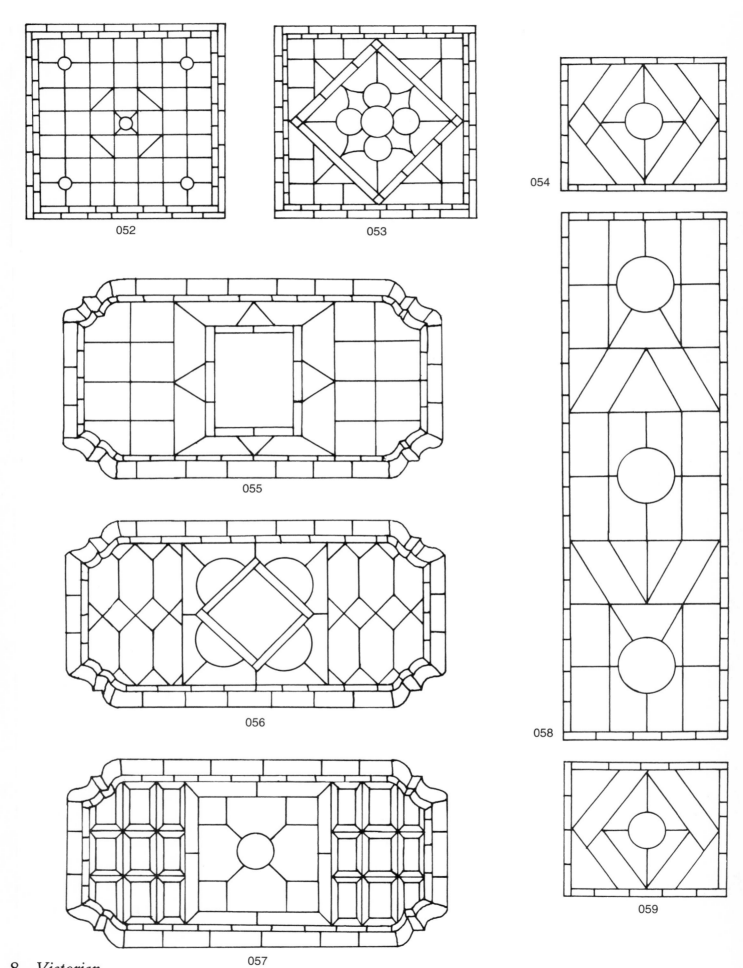

052

053

054

055

056

057

058

059

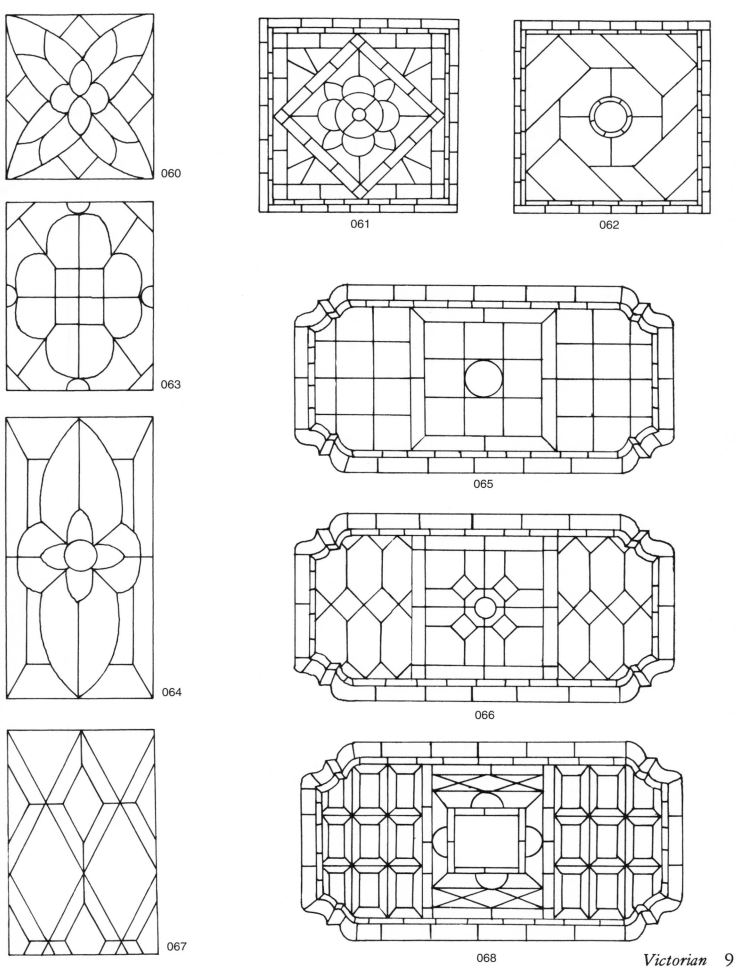

060

061

062

063

064

065

066

067

068

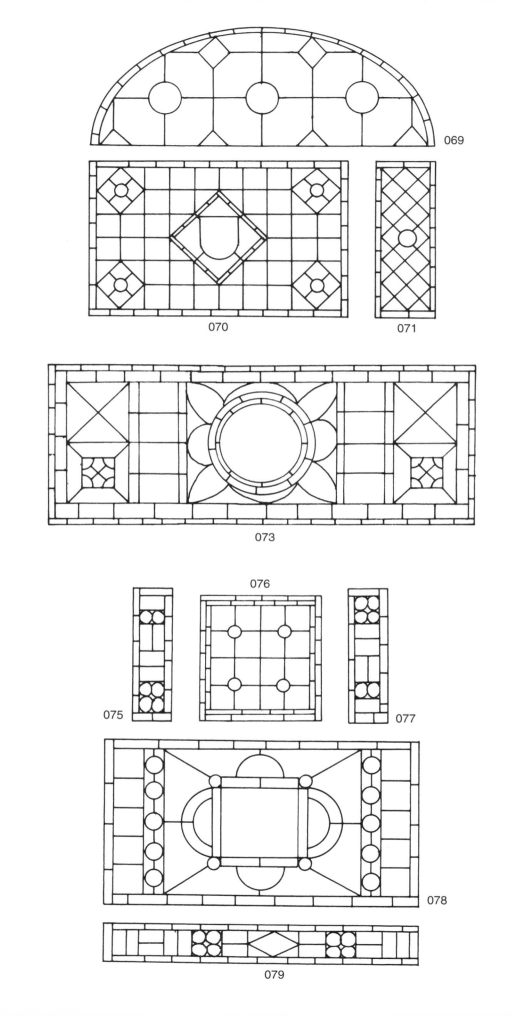

069

070 071

072 073 074

076

075 077

078

079

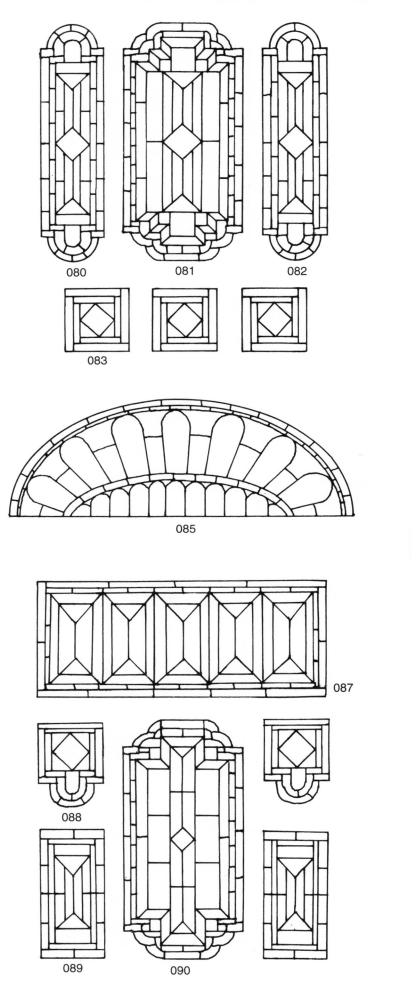

080

081

082

083

084

085

086

087

088

089

090

091

092

093

094

095

096

097

098

099

100

103

101

105

104

106

102

108

107

109

110

111

112

114

115

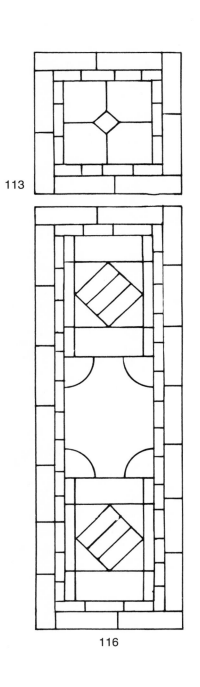

113

116

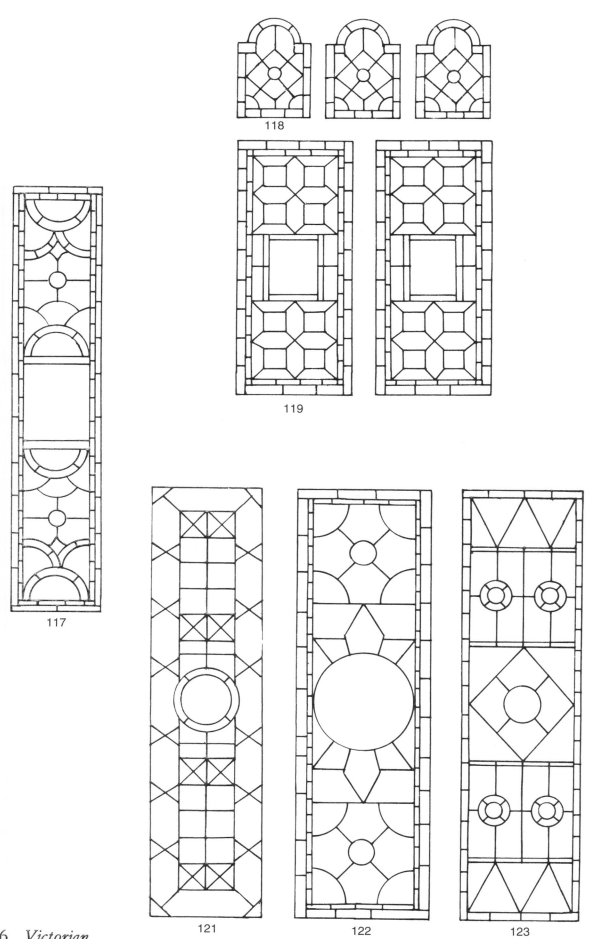
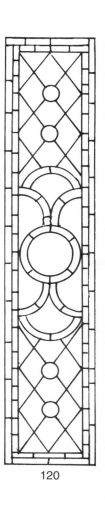

118

119

117

120

121

122

123

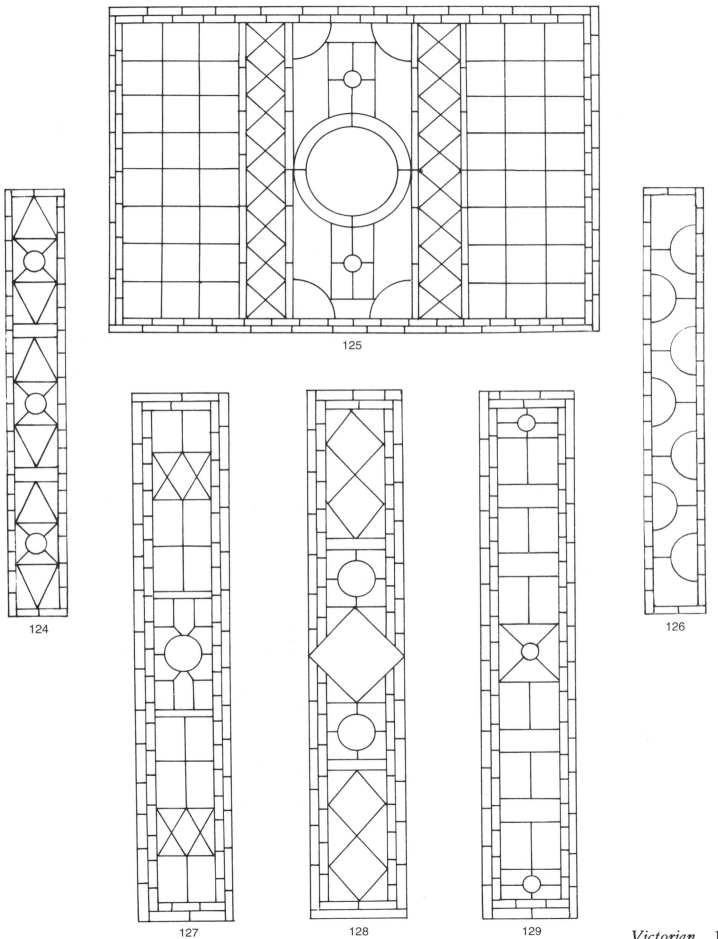

125

124

126

127

128

129

131

132

133

130

134

135

136

137

138

139

140

141

142

143

144

145

146

147

148

149

150 151

152

153

154

155

156

157

158

159

160

161

162

163

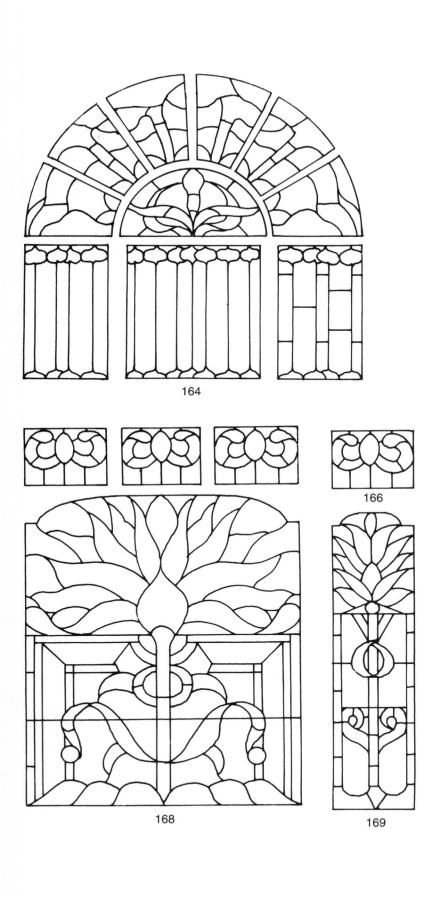

164

166

168

169

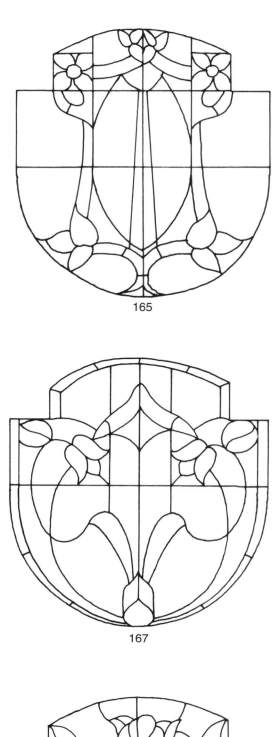

165

167

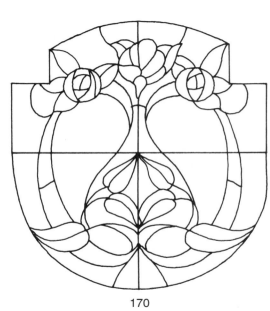

170

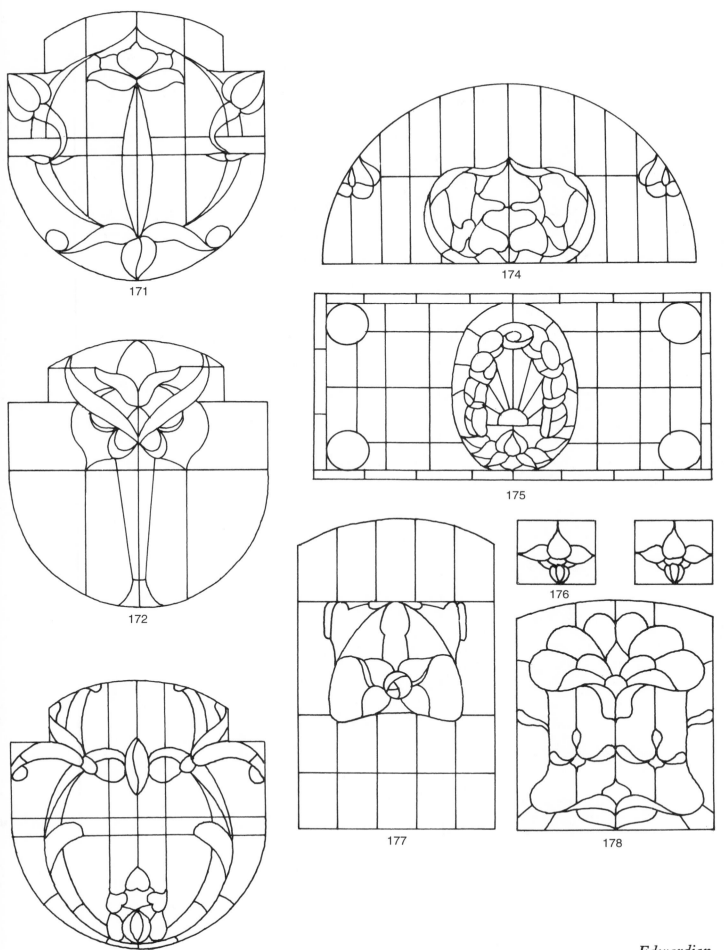

171

172

173

174

175

176

177

178

179

182

183

180

184

181

185

186

187

188

189

190

191

192

193

194

195

196

197

198 199 200

201

202

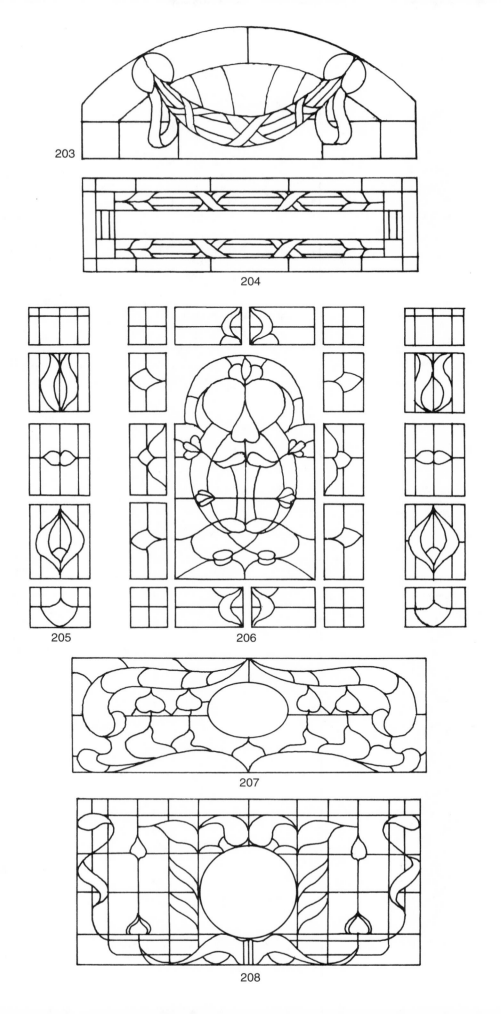

203

204

205

206

207

208

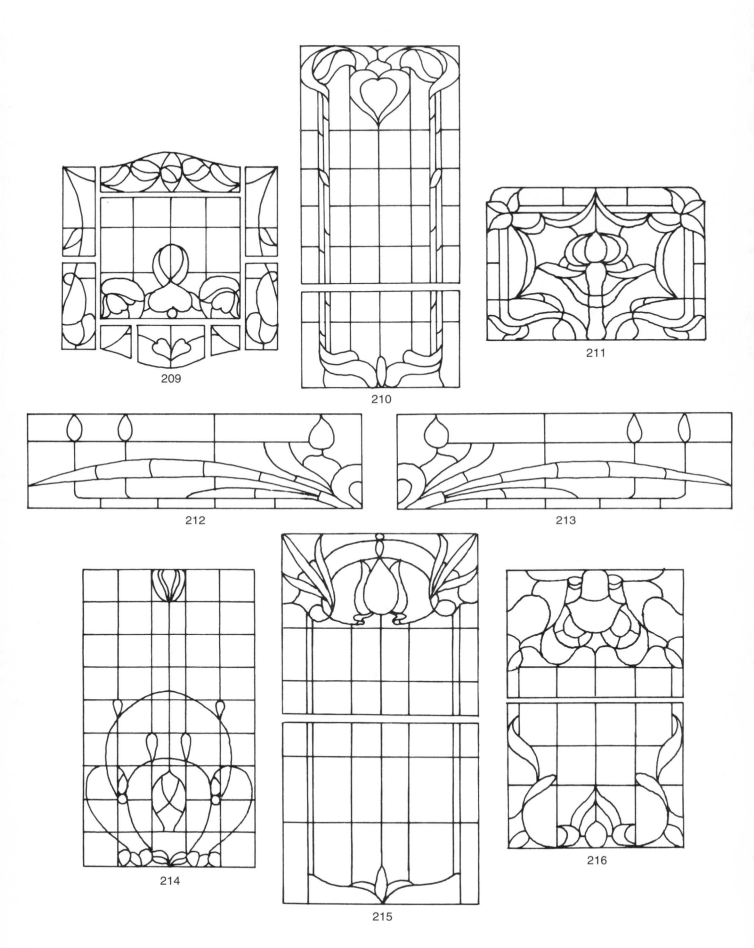

209

210

211

212

213

214

215

216

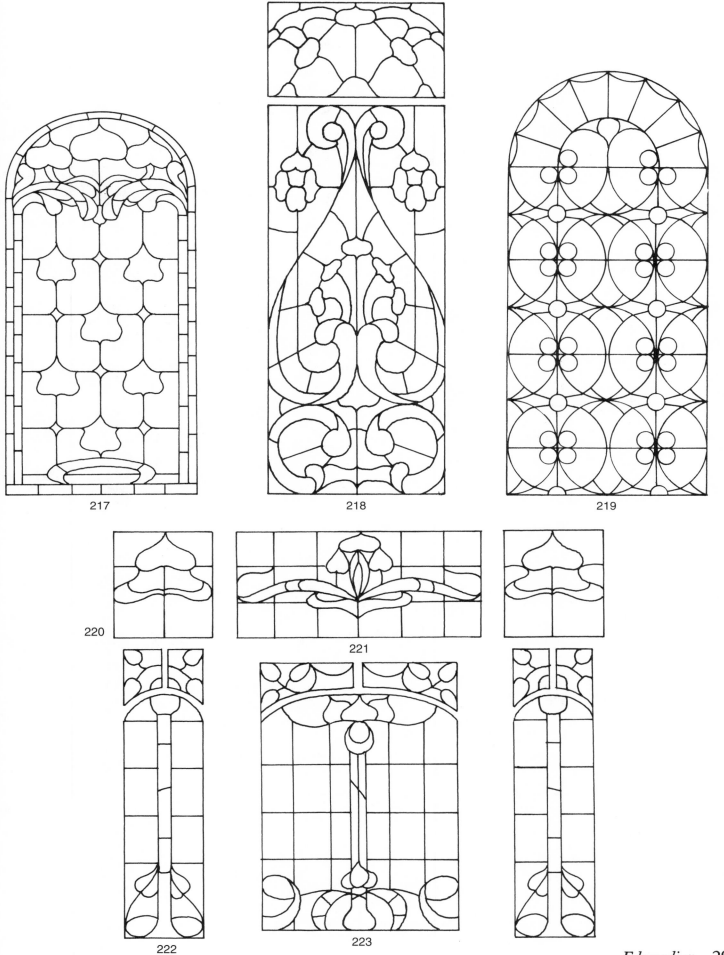

217

218

219

220

221

222

223

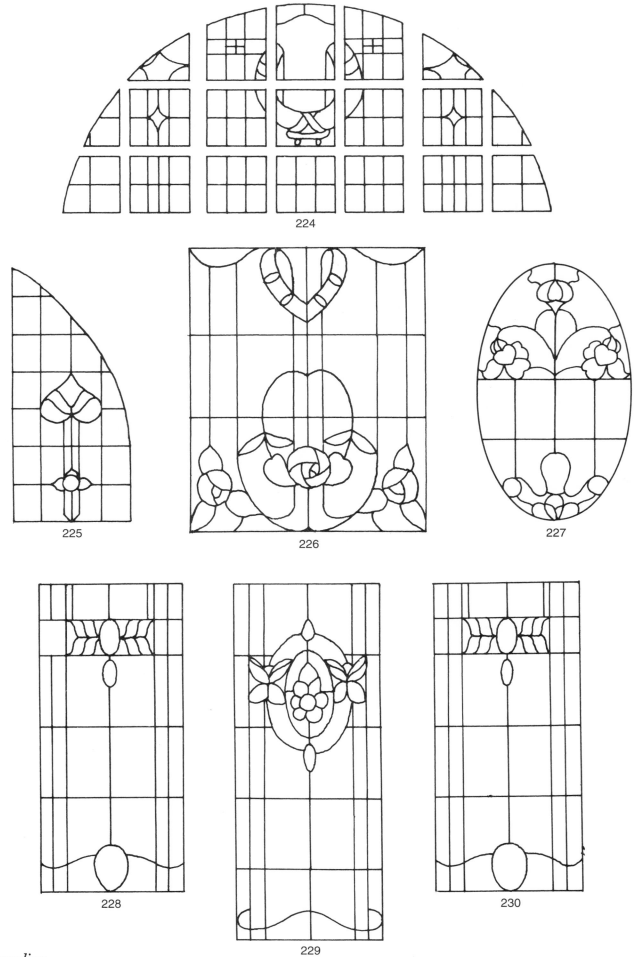

224

225

226

227

228

229

230

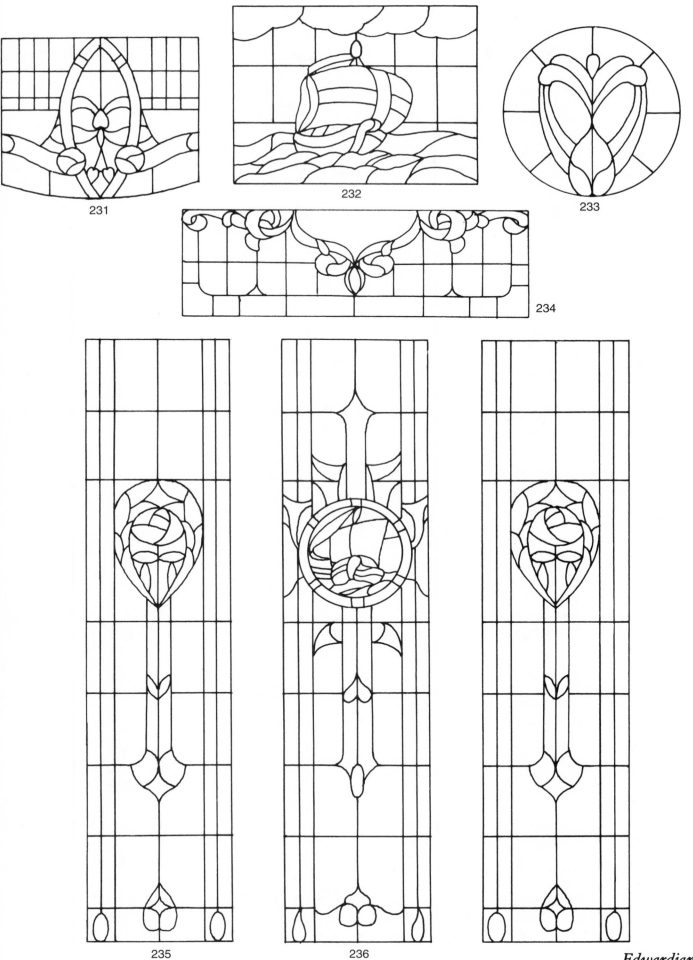

231

232

233

234

235

236

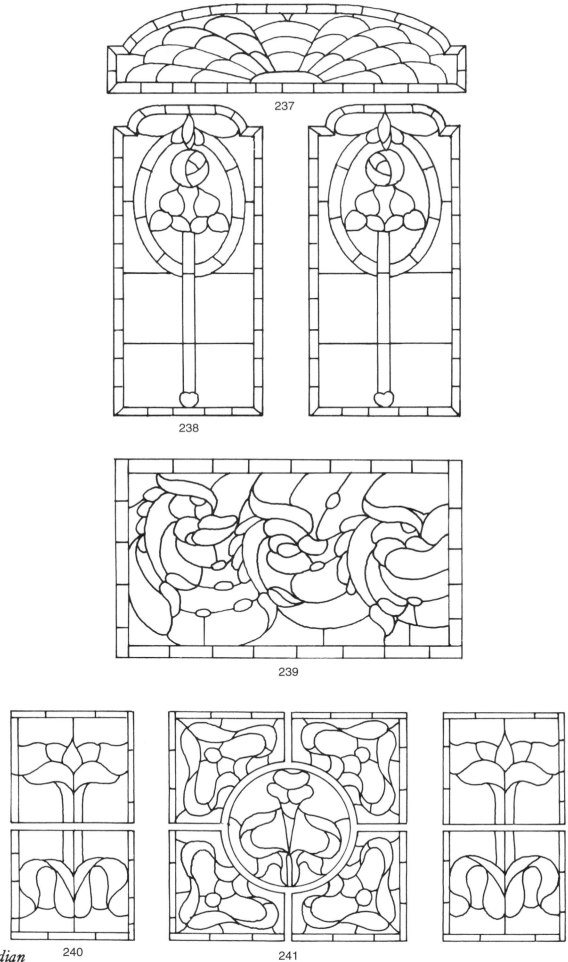

237

238

239

Edwardian

240

241

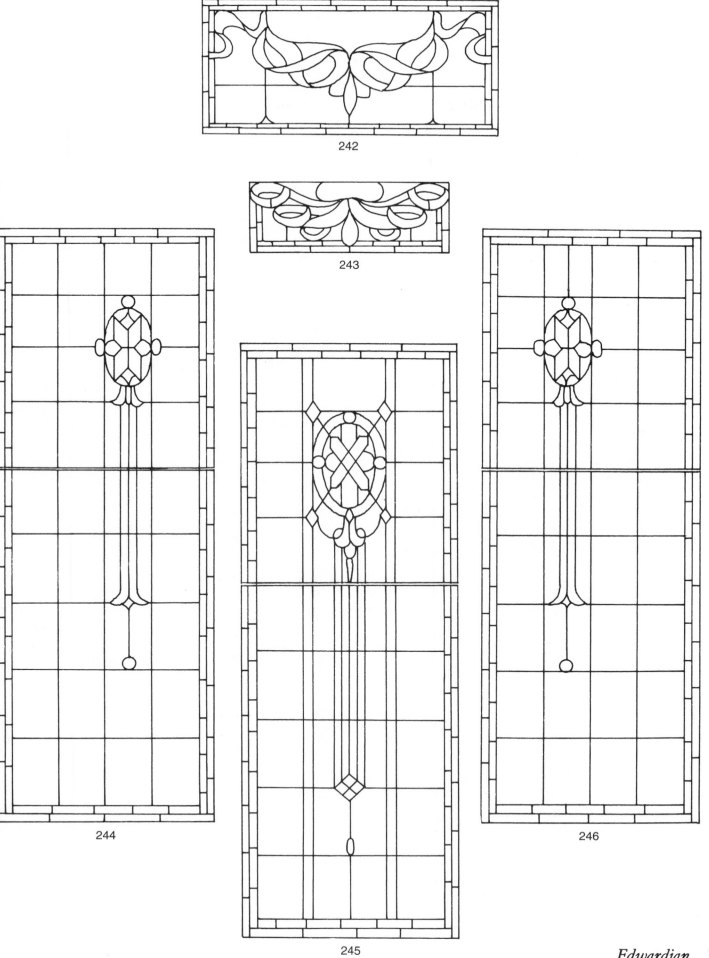

242

243

244

245

246

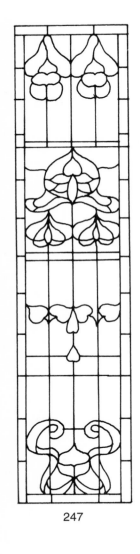

247

248

249

34 *Edwardian*

250

251

252

254

253

255

256

257

259

261

260

258

263

262

264

265

266

267

268

270

269

271

272

273

274

275

276

277

278

279

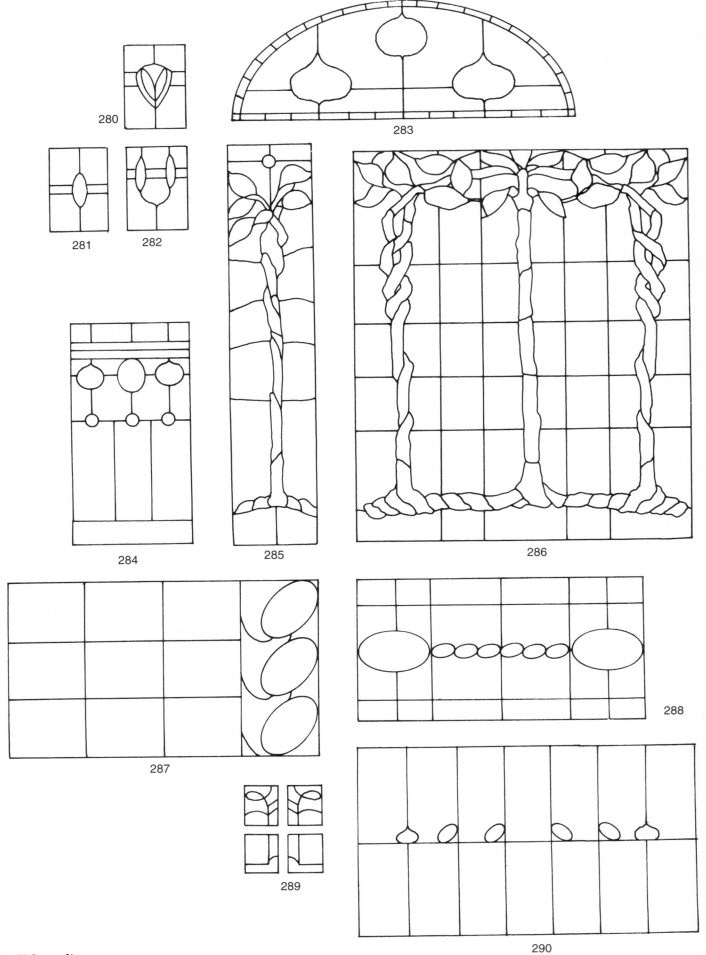

280

283

281

282

284

285

286

287

288

289

290

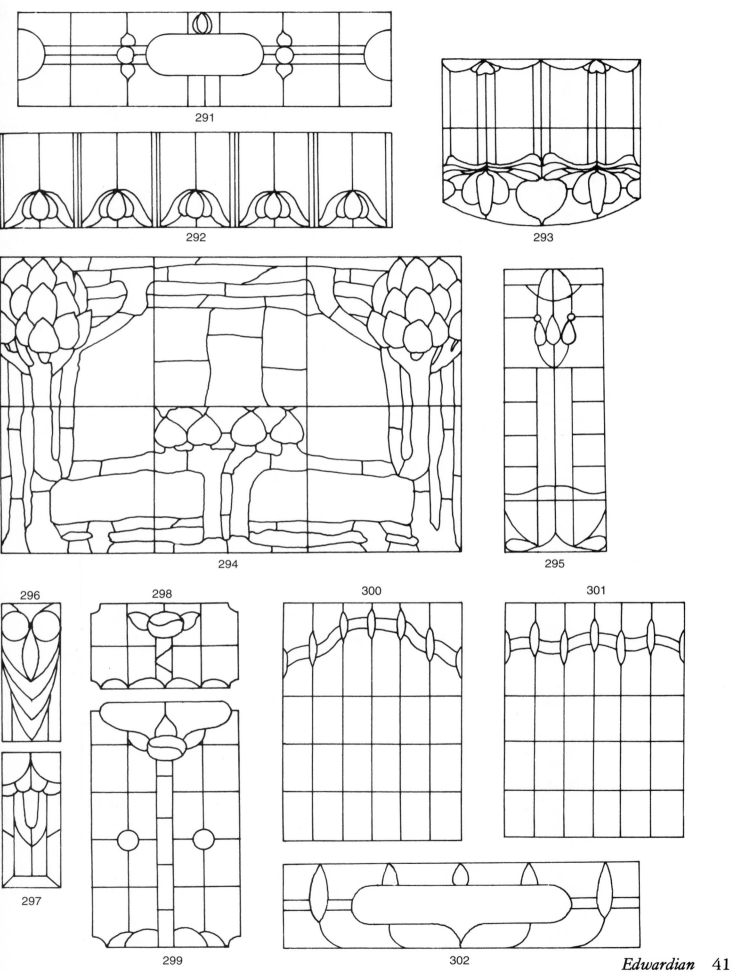

291

292

293

294

295

296

298

300

301

297

299

302

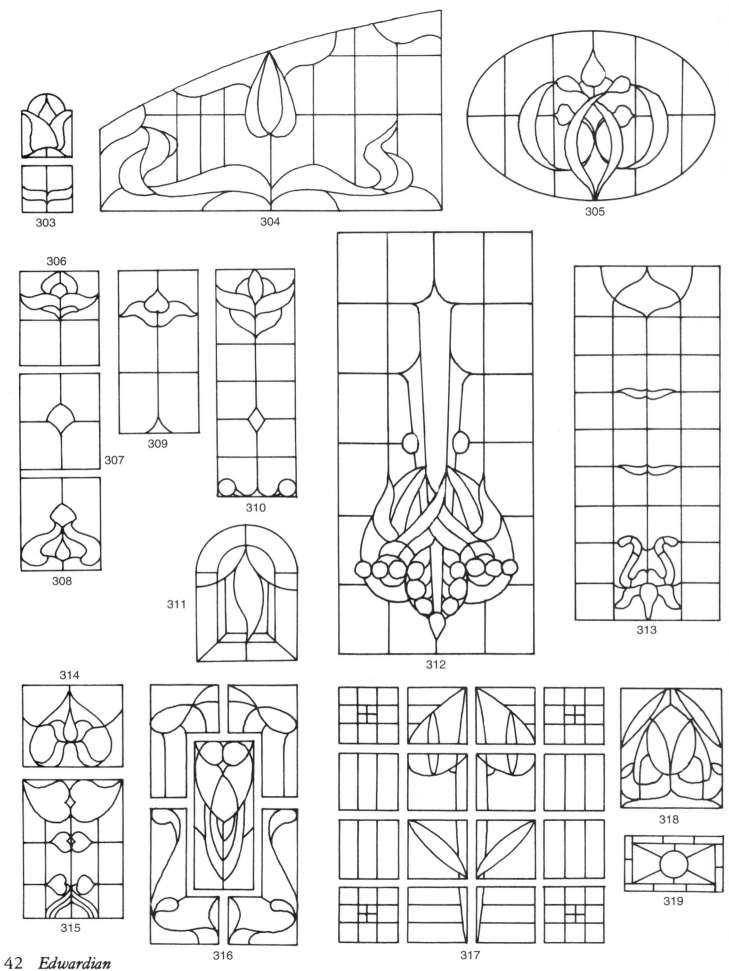

303

304

305

306

307

308

309

310

311

312

313

314

315

316

317

318

319

320

321

322

323

324

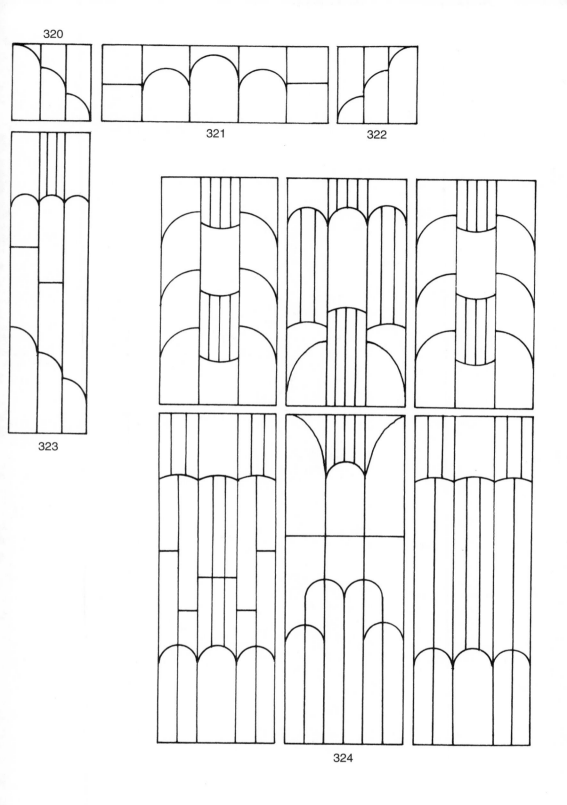

325

326

327

328

329

330

331

332

333

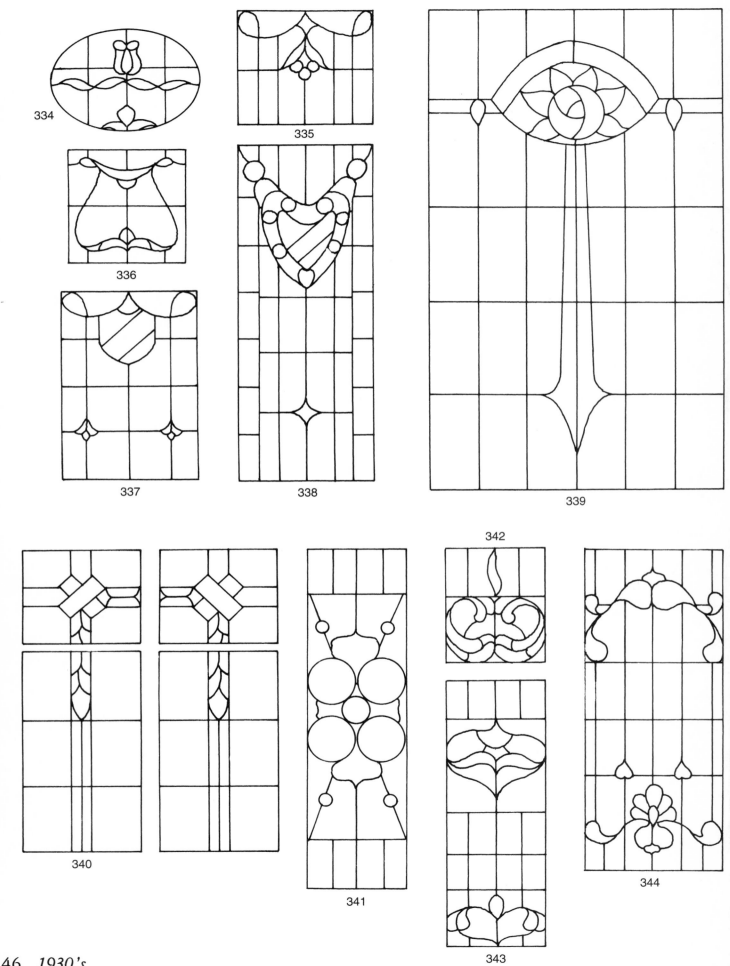

334

335

336

337

338

339

340

341

342

343

344

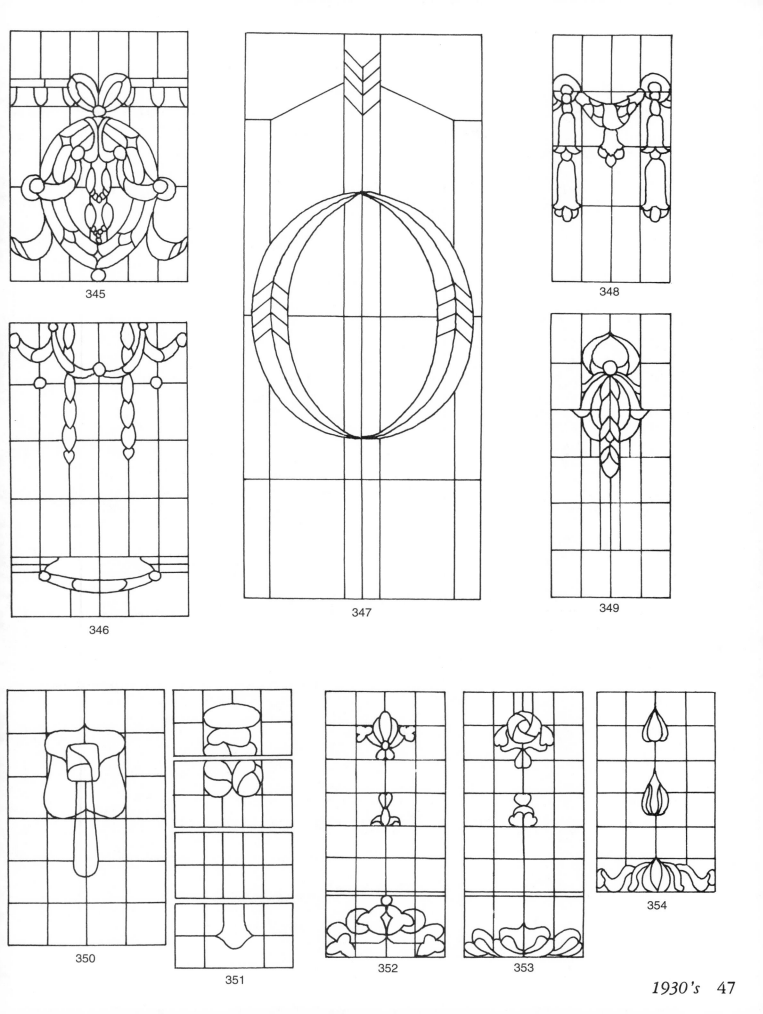

345

346

347

348

349

350

351

352

353

354

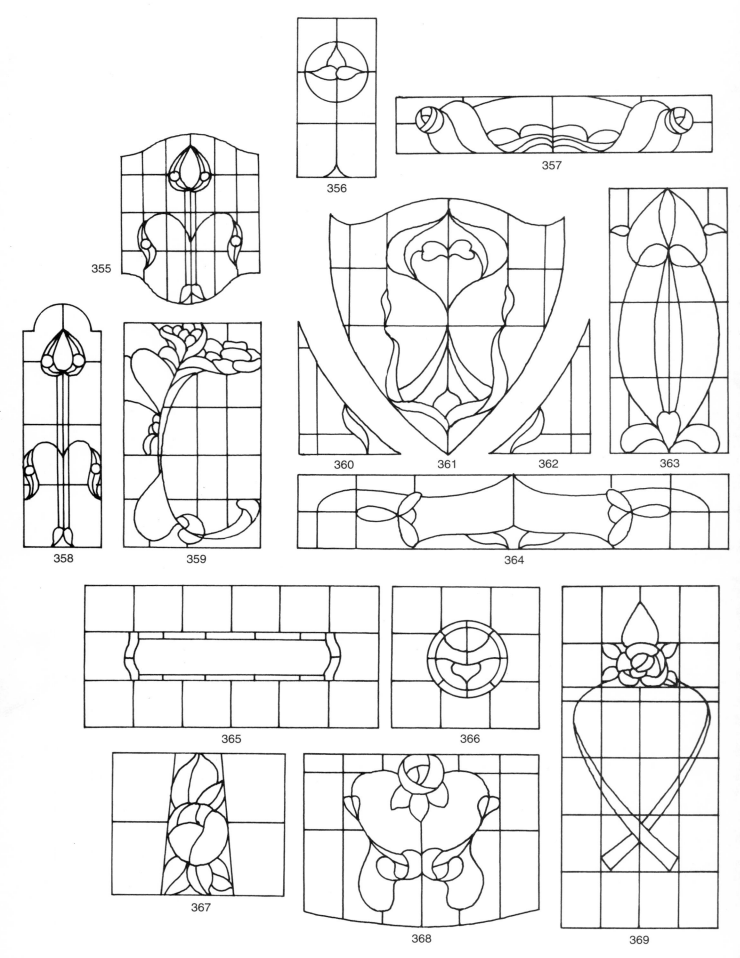

356

357

355

358

359

360 361 362 363

364

365

366

367

368

369

FLY FISHER'S

Pattern Book

FLY FISHER'S

Pattern Book

GENE KUGACH

STACKPOLE
BOOKS

Published by
Stackpole Books
5067 Ritter Road
Mechanicsburg, PA 17055
www.stackpolebooks.com

Printed in the United States of America

10 9 8 7 6 5 4 3 2 1

First edition

Library of Congress Cataloging-in-Publication Data
Kugach, Gene
 Fly fisher's pattern book/Gene Kugach—1st ed.
 p. cm.
 ISBN 0-8117-2759-9 (pbk.)
 1. Fly tying. 2. Flies, Artificial. I. Title.
 SH451.K84 2000
 688.7'9124—dc21
 99-053962